創造優雅靈魂

Jewellery design by Liliana

盧春雄
臺灣珠寶藝術學院

設計「Design」一字源自拉丁文的「Designare」，原意就是英文的「Designate（賦予 / 指定）」，賦予一個事物意義。林汶諭 (Liliana Lin) 小姐應用個人獨特的「心智圖」模式創作珠寶，賦予每一件珠寶首飾意義，讓訊息超越事物本身就是設計的意義創新！

設計是一種融合「美觀、實用、價值」於完美境界的藝術表現，藉由設計師的涵養與意念，昇華轉化成語彙形式實踐。從汶諭的珠寶設計作品中，可以充分反映出她對「材料、工藝、功能」有相當程度的修養，她能在「物質」和「技術」條件的允許下，實踐產出符合人體工學，並賦予首飾生動、完美、健康、和諧的藝術形象，令我讚賞。

每一個事物都有一個非常好看的角度，設計任務就是擷取這個角度，使之成為永恆。珠寶首飾設計不但要考慮到佩戴的舒適性，更要追求裝飾美化的功效。造形的美不僅是消費要求，實際上更是賦予裝飾品的基本價值。汶諭 (Liliana) 所勾勒或形塑出的造形中，無論是以「形式表現」手法，或是「內容設計」方式，均能把握住珠寶的特色，很自然地顯露出一種獨有的心智美學，值得您平靜思辯。

很驚喜，珠寶設計師林汶諭 (Liliana Lin) 願意將自己構思模式分享給大家，讓大家可以一窺隱藏在珠寶首飾後面的設計思維，讓更多人具體的認識到每一件作品是如何地與眾不同。期許，更多的創意巧思，激起更多的熱情喜愛，只為珠寶，成為珠寶。

Lu Chun-Xiong
Taiwan Jewellery Arts Institute

The English word 'design' is derived from the Latin 'designare'. Its original meaning was the English 'designate' (endow/ assign), to endow something with meaning. Ms. Liliana Lin uses her own individually unique 'mind map' to create jewellery, endowing each piece of jewellery with meaning, and letting the message transcend the item itself, which is the meaning of innovation in design!

Design is something that combines 'beauty, practicality, and value' in a perfect state of artistic expression. It uses the self-possession and ideas of designers, and on a sublime level transforms them into the vocabulary of form and practicality. Liliana's jewellery design works are able to fully reflect her considerable degree of self-possession and self-cultivation in terms of 'materials, craft, and functionality'. As far as is permitted by the 'material' and 'technical' conditions, she is able to practice the production of individually ergonomic jewelry that has been endowed with vivid, perfect, healthy and harmonious artistic imagery, which I find admirable.

Every item has a very visually attractive angle. The task of design is to take this angle and make it eternal. Jewelry design has to not only consider the comfort of wearing jewelry, but moreover also pursue the effects of decorative beautification. The beauty of shape is not only something demanded by consumers, but is in fact what endows a jewelry product with its basic value. The outlines or shapes brought out by Liliana, whether they are created through an 'expression of form' or a 'content design' approach, are all able to capture the special characteristics of jewelry, and very naturally reveal a unique kind of mental aesthetics, which is worthy of your serene contemplation.

Surprisingly, jewellery designer Liliana Lin is willing to share her ideas with us all, allowing all of us to get a glimpse of the design thinking hidden behind the jewellery, so that more people will be able to gain a concrete understanding of how each piece differs from the rest. It is anticipated that more creative ingenuity, and more enthusiasm will thus be aroused, just for jewelry, and how it comes into being.

序

每個女人的心目中都有一件屬於自己完美的珠寶，這一件完美的珠寶要能夠襯托出主人的性格、符合主人本身的個性，更要展現出特殊身分與地位的象徵！在珠寶設計的領域裡面，珠寶設計師發揮出自己的想像力讓珠寶發光發熱，以成就出一件完美的珠寶，展現最完美的效果！

一件珠寶的誕生需要非常多的工序與環節，這些環節要能夠互相溝通、相互運作才能產生出一件完美的作品！從設計發想開始，到手繪稿出爐，找材料，搭配色石、討論金工工藝的工序與施作方法、討論電鍍與拋光能夠呈現出特殊的效果，每一件作品所考量的狀況都不一樣，但是基本原則是所有的設計都是在凸顯與襯托主石的架構下發展出來的。一件用心的作品常常需要費時數個月到一年，甚至更久！我們常常看到一些知名的大型珠寶，費時幾年才完成。所以尊重每一件珠寶的誕生，是我們最基本的態度，這也是對珠寶喜好者的一個負責任的態度。

關於這一本的書籍的出爐，要感謝很多人。感謝我的金工製作團隊、感謝攝影師呈現出珠寶的本質，豐富了這本書的可看性！更要感謝每一位教導過我的老師，沒有他們的付出就沒有這本書的誕生。這本書希望能夠提供給珠寶設計愛好者一些學習方向與適切的建議。所以，我利用一些設計方法來引導閱讀，分享我的設計思考與方法。期望未來能夠做得更盡善盡美，繼續以書會友，來和大家見面。最後，最重要的是感謝您的支持！

Every woman image an idea of what her perfect piece of jewelry should be like. This perfect piece of jewelry should be able to highlight the character of its owner, conform to its owner's personality, and moreover, reveal itself as a symbol of a unique identity and status! In the field of jewelry design, jewelry designers bring their imaginations into play to allow jewels to glow and emit warmth, to create a perfect jewel that brings out the most perfect effects!

There are thousands of work processes and linkages between them that are required for the birth of a piece of jeweler. These linked elements must be able to communicate with each other and work in conjunction with each other for a perfect piece of work to be produced! This begins with the creative spark of inspiration behind the design, and progresses to the creation of a hand-drawn blueprint, then to finding the materials, matching the colored stone, discussing the work processes and application methods of the metalworking craft, and discussing the metal plating and polishing best able to bring out the particular effects desired. The conditions to consider are different for every piece of work. However, a basic principle is that all designs are developed within a framework of highlighting and setting off the main stone. The time needed for the creation of a first-rate piece of work can often run from several months to a year, or even longer! We frequently see some well-known, large items of jeweler that take several years to complete. This is why respecting the birth of every piece of jewelry is our most basic attitude, and this is also a responsible attitude for jewelry lovers.

With respect to the release of this book, there are many people I would like to express my thanks to. I would like to thank my metalworking team, and the photographer for capturing the essence of jewelry, and thereby enriching the book's visibility! I would also like to thank every teacher who has taught me; without their efforts, this book would never have come to be. This book hopes to provide jewelry design enthusiasts with some learning directions and appropriate advice. Hence, I have utilized some design methods to guide their reading and I have shared my design thinking and methods. I hope in the future to be able to contribute more consummate and superlative written work and continue to meet friends out of literary. Last but not the least, thank you for your support!

淺
談
設
計

筆者在這裡所使用的字眼是「設計」，而不是「珠寶設計」。設計思考 (Design Thinking) 創造的開端與架構在一開始的基礎上都是一樣的，只有進行到設計思考末端時，才開始有分歧的現象出現，這時候會出現「可執行化」的概念出來，那是因為設計還是要回歸到主架構，必須是「可執行」、「可實現」的狀態下。不然，很容易成為漫天想像的，那都不是我們所樂見的！

在筆者還是學生的時候，創造設計思考 (Design Thinking) 這件事，一直是我的生活主軸。筆者相信透過一系列的邏輯性思考與系統化的訓練，就不需要事事依賴靈感！ Tim Brown 曾在《哈佛商業評論》（Harvard Business Review) 這樣定義：「設計思考是以人為本的設計精神與方法，考慮人的需求、行為，也考量科技或商業的可行性。［註］」所以，這裡以「人為本的精神出發與方法」，除了更強調感性層面之外，其實同時也探討了商業行為的價值，創造一系列以「需求」為主進行的思維訓練與行銷價值的體系。

所以，筆者習慣使用兩個訓練方式，這兩個訓練方法可以成為一個小組一起運作，也可以獨立進行。富有相當高度的彈性。在這本書中，筆者會針對腦力激盪與心智圖做簡單的介紹，這也是我一直很慣用的思考方式，因為筆者相信這對設計人會有莫大的幫助！

［註］哈佛商業評論 June 2008. 頁 85.

I've used the term 'design' here, rather than 'jewelry design.' The initial stages and structure of design thinking start out fundamentally the same for all design. Only when we come to the end of design thinking will there be any divergence. At this time, the concept of making the design "executable" will emerge. That is because the design still has to return to the main architecture, and it must be "executable" and "realizable". Otherwise, it can easily become pie in the sky, which is not something we are happy to see!

When I was a student, creating design thinking was always what my life revolved around. I believe that by using a series of logical thinking and systematic training, people don't need to rely entirely on their own inspiration! Tim Brown has defined this in the Harvard Business Review: "design thinking-a methodology that imbues the full spectrum of innovation activities with a human-centered design ethos. [1] " Thus, here, through a "design thinking-a methodology that imbues the full spectrum of innovation activities with a human-centered design ethos.", in addition to putting more emphasis on the perceptual level, at the same time, we also focus on the value of business conduct and creating a series of systems of thought training exercises and marketing value based upon "demand".

Therefore, I habitually use two training methods. These can be operated as a group, or can also be carried out independently. They are highly flexible. In this book, I will give a brief introduction to brainstorming and mind mapping. These are also approaches to thinking that I have become very much accustomed to using, because I believe they will be very beneficial to designers!

[1] Harvard Business Review June 2008. p.85

腦
力
激
盪

腦力激盪法（Brainstorming），又稱為頭腦風暴法，這是一種為激發創造力、強化思考的方法。它可以獨立運作，亦可多人一組。廣告公司創始人亞歷克斯 · 奧斯本（Alex Faickney Osborn）於 1938 年首創的，這個方法在很早以前就一直為人所津津樂道。

腦力激盪法伴隨筆者度過學生時代，確實為我的設計提供一條很特別的道路。在學生時期，筆者曾經參加一個創意訓練的課程，當時的訓練方式為五人一組，其中一位是記錄員。每天的訓練方式很特別，需要對於一件物品使用聯想法，時間以三分鐘為限，需要提供 50-100 個不同的建議，來達到目標。因為，筆者參加的主軸是設計思考訓練，所以多半從商品角度出發，而非管理或行銷面向。這個方式可以提供給設計愛好者使用，間單有效。

但是，腦力激盪法雖然有效，但是仍有幾個準則需要提醒。
 1. 時間不宜太久，容易造成思考疲乏。建議以 3-5 分鐘為限。
 2. 多人一組的效果通常比一個人更好。可以更有效刺激彼此的想像力。

腦力激盪之後的小組討論與檢討也相當重要，千萬不能忽略！

Brainstorming, also known as racking one's brains, is a technique used for stimulating creativity and improving thinking. It can be applied alone or by group. Alex Faickney Osborn, the founder of an advertising agency, first created this approach in 1938. This method has been discussed in elaborate detail for many years now.

The brainstorming method accompanied me throughout my student years, and it really did provide me with a very special path for my design work. During my time as a student, I once participated in a creativity training course. The training method used at that time was to have a group of five people, one of whom was a recorder. The daily training method was very special. We had to use association of ideas for one specific item, with a three minute time limitation and we needed to provide 50 to 100 different suggestions to achieve the goal. Because the main driving force behind my participation was to train in design thinking, most of those I suggested came from the perspective of commodities, rather than management or marketing. This method can be utilized by design enthusiasts. It is simple and effective.

However, although the brainstorming technique is effective, there are still several guidelines that need to be kept in mind.
1. The time spent on this should not be too long, as it can easily cause mental fatigue. 3 to 5 minute for one session are recommended.
2. The effect of a group brainstorming is usually better than brainstorming alone. This is because it can more effectively stimulate each other's imagination.

Group discussions and reviews after brainstorming sessions are also very important, so don't neglect to do these!

心
智
圖

心智圖 (Mind Mapping)，又稱心智地圖、思維導圖。

這是由 Tony Buzan 於 1970 年所提出的輔助思考工具，這是一種使用關鍵用詞與聯想法的全腦式訓練思考方法。這是一個很有趣的思考設計訓練，在聯想中建立關聯性，可以天馬行空，刺激想像力與創造力！

筆者很喜歡利用心智圖來做為思考設計流程的開端。這不是一本教科書，所以筆者也不喜歡鉅細靡遺的闡述，先遵守下面簡單原則，再發展出自己的特色心智圖，心智圖是一份沒有對錯的思考邏輯，用一個開放的心去創造，相信每個人都能創造出無限的想像力。

- 從中心點出發，開始繪製「主題」。
- 在中心點旁邊發展出主枝幹，成為主要概念或意念來輔助思考。
- 可使用文字／圖像／圖文並茂／圖文 + 色彩。筆者建議使用圖文並茂更有趣。
- 心智圖可以成為樹枝狀或魚骨圖，圓型關聯式圖型都可以，完全不受限。
- 可以加入色彩來發揮情緒會感覺的狀態。例如：紅色是熱情、危險…。
- 進行想像力創造，既可以使用關聯性，也可以使用對比性質。不需受限。

 例如：魚，可以聯想到水（聯想法）。

 例如：水，可以聯想到火（對比法）。

Mind Mapping, also Known as "Mental Mapping", or "Thought Guidance Mapping".

This is an assistive thinking tool proposed by Tony Buzan in 1970. This is a pan-cerebral mental literacy technique that makes use of key words and association of ideas. This is a very interesting form of training in design thinking, which builds relevance in association of ideas. With this, you can give free rein to your ideas, stimulating your imagination and creativity!

I really like to use mind mapping to serve as the inception of the ' design thinking' process. This is not a textbook, so I would prefer not to elaborate on the details. First follow the simple principles below and develop a mind map with your own characteristics. A mind map is a form of thinking logic without right and wrong. Please keep an open mind in creating one of your own. I believe that everyone is capable of creating unlimited imagination.

- Beginning at the map's center point, start drawing "themes."
- By the sides of the center point develop the main branches, these become the main concepts or ideas to help you think.
- Can use text / images / quality images with suitable accompanying text / images with text + colors. I recommend quality images with suitableaccompanying text as these are more interesting.
- A mind map can take on a tree-like form or resemble a fish-bone diagram, or a circular correlation graph can also be used; you are completely unrestricted.
- You can add colors to bring out the state of emotions you will feel. For example: red symbolizes passion, or danger...
- Go ahead using your imagination to create. You can use association, or you can also use things of a contrasting nature. You have no limitations.
 For example: fish, this can be associated with water (association of ideas method).
 For example: water, this can be associated with fire (contrasting ideas method).

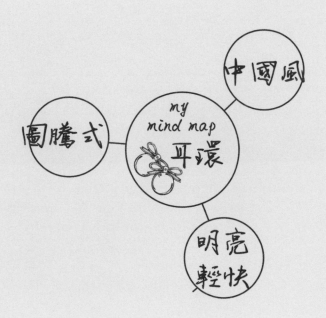

步驟一、　先決定出中心點－設計主題。

步驟二、　從中心點開始向外發展，以概念與意象為出發點。以這個例子來示範：我想使用中國風、圖騰式、明亮輕快當我的設計概念。

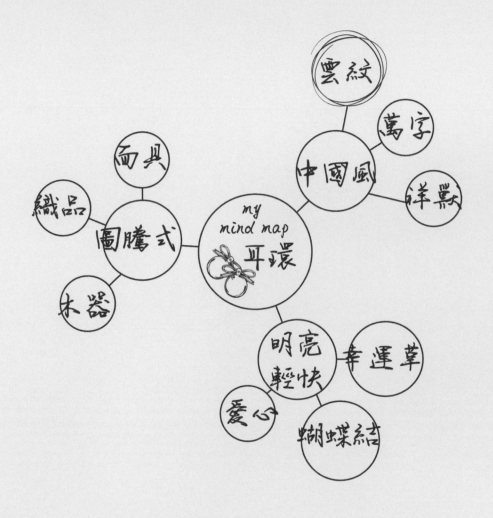

步驟三、　從設計概念繼續往外延伸。舉例：中國風的概念裡面，開始進行創意思考的聯想，這裏聯想到
　　　　　中式的雲紋、傳統的萬字結、代表吉祥的祥獸。再從這些發展出來的想法當中找尋適合的主題。

Jewellry must be quiet, graceful, and dreamy.

作品賞析

Appreciation of fine artworks

看見春天

Seeing Spring

當我看到這個珊瑚的時候，就深深被本身姿態所吸引。這個姿態並非流線有動態，反而呈現出一種安靜的形態。因為這支珊瑚原枝相當具有重量（高達 15.6g），當我進行設計的同時，我需要考慮到配戴者本身的舒適性與重量感，所以在設計上就盡量以流線且輕盈的視覺感受為主軸。希望在考慮到設計的同時，更能為配戴者保留住寶石本身珍貴的質感與舒適性。

When I see this coral, I was deeply attracted by its posture. This posture did not have a line of dynamic flow, rather it exuded a form of quietness. Due to the fact that this coral's originally weighed a lot (up to 15.6g), when I was in the process of designing, I had to take into consideration the comfort level and how heavy it would feel for the wearer. Therefore, I incorporated lines and light visual feeling as core elements as much as possible in my design. I hope that while I'm considering the design aspect, I have also preserved the precious texture and comfort of the gemstone itself for the wearer.

16g 正紅色的阿卡珊瑚	16g Red Aka Coral 14.66g
11.29g 18k 金	11.29g 18K Gold
0.36ct 鑽石	0.36ct Diamonds
0.19ct 桃紅色藍寶石	0.19ct Pink Sapphires

珠寶設計：林汶諭	Jewelry designer: Liliana Lin
珠寶金工：錡儷工坊	Jewelry goldsmith: Qi-Li Jewelry Workshop
攝影：許文星	Photographer: Wen-Hsing Hsu

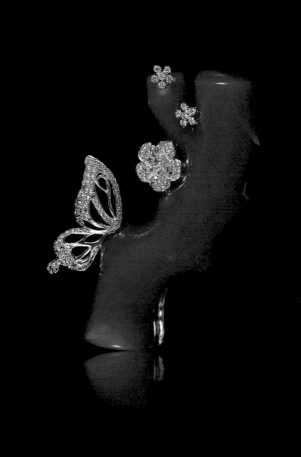

心智圖
Mind Map

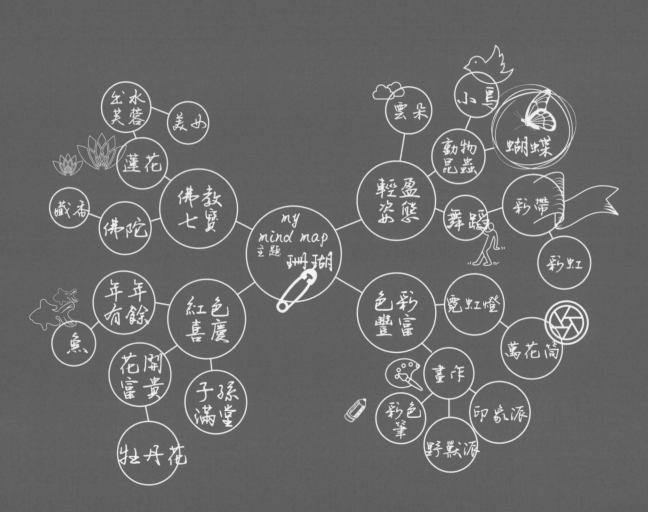

設計發想過程

Concept Development

① ② ③ ④

為了讓主石－珊瑚能夠增加一些輕盈的元素，所以選擇了蝴蝶，試圖創造一個輕盈跳躍的意象。蝴蝶姿態非常多，當決定好主題之後，選擇一個姿態符合寶石的元素更為重要。

選擇的側邊姿態的蝴蝶，希望能夠呈現更輕盈的效果。而避免了繁重的形像呈現在珊瑚上。

決定好題材，就開始進行蝴蝶變形的工作。這裡考慮把蝴蝶的斑紋變小當成鏤空的部分。這個部份決定設計本身的優劣與否，故更顯重要。

外型確立之後，這時候需要特別注意寶石鑲嵌的方法與展示的角度與立體度。到這個步驟，設計基本流程就告一個段落。後面接續著重要的製作流程。

這隻珊瑚有個迷人的特性，顏色正紅色且而討喜，仔細看還帶有一些微微的透度，內行人將這種珊瑚特質稱為玻璃質，無形中增加了珊瑚的靈性，像極一個水汪汪的眼睛一樣。這支珊瑚原枝本身具有優美的姿態與輕巧的身影，所以我的第一個想法就是搭配這個原枝來做一個流動而優雅的造型，但是又不能搶了珊瑚本身的風采，所以我選擇用中國人喜歡的體裁：金魚。來表現出一個美妙又融合胸針造型之外，還有中國人喜歡的吉祥含意，有魚＝有餘。

This coral has an attractive characteristic, the color is pure red and it is also very likable. If you look closely, you can see that it is also slightly translucent. Experts call this special coral trait vitreous, inadvertently increasing the coral's spirituality, very much like a bright eye. This coral's original form possessed an elegant posture and a light silhouette. Therefore, my first thought came up with a fluid yet graceful design to complement the original coral piece, without taking away the coral's own elegant demeanor. So I chose a genre that Chinese people like: goldfish. In addition to displaying the wonderful and incorporating brooch design, there is also the auspicious meaning that Chinese people like, you-yu (there's fish) = you-yu (there's surplus).

11g 正紅色的阿卡珊瑚	11g Red Aka Coral
14.66g 18k 金	14.66g 18K Gold
0.37ct 鑽石	0.37ct Diamonds
0.56ct 桃紅色藍寶石	0.56ct Pink Sapphires

珠寶設計：林汶諭	Jewelry designer: Liliana Lin
珠寶金工：錡儷工坊	Jewelry goldsmith: Qi-Li Jewelry Workshop
攝影：許文星	Photographer: Wen-Hsing Hsu

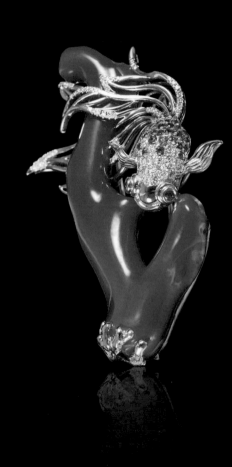

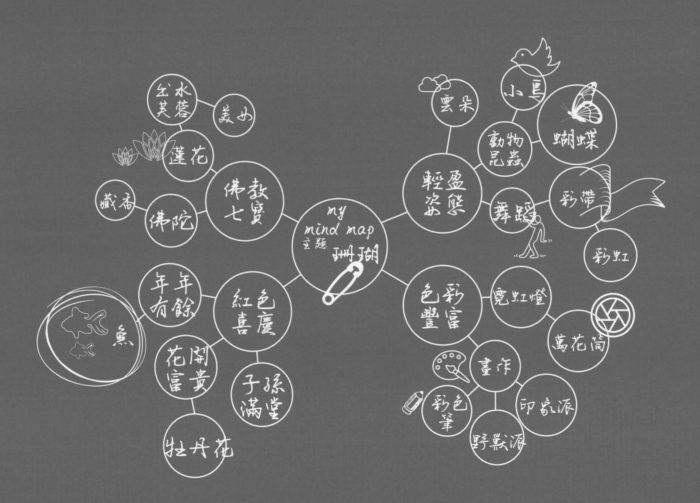

設計發想過程

①

②

③

④

① 珊瑚原枝是比較有重量且厚實的寶石，這裡使用輕盈的概念來做為設計元素。嘗試在各式魚種裡面找到一個比較活潑的形象來當做體裁。

② 最終考慮了金魚，除了本身體活潑有動感之外，也希望能夠賦予特別的涵意。年年有餘之意象。

③ 決定好金魚為題材之後，一樣需要進行困難的變形工作。為了將尾巴製造出靈活的感覺，花費不少時間。這個部分如果呈現的不理想就很難表現出輕盈的感覺。

④ 外型確立之後，因為想呈現出魚與珊瑚之間的動態。所以這裡的施工就需要各部分獨立進行之後，製造完成再進行組合。

一抹綠

A Touch of Green

中國是一個尚玉的民族，然而翡翠進入中國時間並不長。在清朝，翡翠，有好多別名，雲玉、水綠玉、滇玉、翡翠。翡翠給人的形象總是貴氣的，所以我想悄悄地扭轉一點效果，讓輕熟女也能適合配戴，但一樣能展現高雅。所以我設計了流暢的線條，來包覆珍貴的翡翠。

China is an ethnic group of people who admire jade, but the amount of time that emerald has been in China has not been very long. In the Qing Dynasty, jade had many other aliases, such as cloud jade, water green jade, Yunnan jade, and emerald. The image of emerald has always been noble, which is why I wanted to quietly create a slightly different effect, so that young women can also be suitable for wearing emerald, and still show the same level of elegance. Therefore, I designed smooth lines to cover the precious emerald.

4 顆　陽綠色翡翠	4 pcs　Green Jade
6.41g　18k 金	6.41g　18K Gold
1.45ct 鑽石	1.45ct　Diamonds
尺寸：12.12mm × 31.05mm	Dimensions: 12.12mm × 31.05mm
（單個尺寸）	

珠寶設計：林汶諭	Jewelry designer: Liliana Lin
珠寶金工：錡儷工坊	Jewelry goldsmith: Qi-Li Jewelry Workshop
攝影：許文星	Photographer: Wen-Hsing Hsu

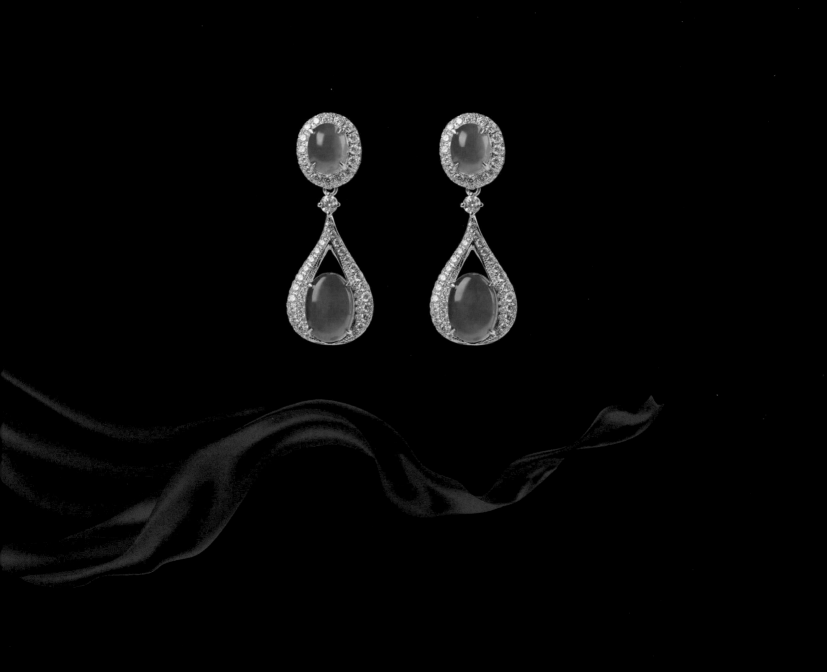

我的哥德式印象
My Gothic Impression

2016 年的九月我來到英國的 Salisbury Cathedral，這種哥德式的建築，尖塔高聳、尖型拱門的教堂，深深吸引我。這個成為我創作的一個重要印象元素。當高聳的花窗玻璃化身為鑽石、尖型拱門變成線條，珊瑚在此刻化成為一個接受讚嘆的造物主。

I came to Salisbury Cathedral in the UK in September 2016. This church, aGothic building with its steeple of the tower, and pointed arched doorway, attracted me deeply. This has become an important image element of my creation. When the towering stainless glass windows became the embodiment of diamonds and pointed arched doors turned into lines, the corals become the creator of all things that accepts admiration.

2.764g 阿卡珊瑚	2.764g Red Aka Coral
12.26g 18k 金	12.26g 18K Gold
2.32ct 鑽石	2.32ct Diamonds
0.16ct 紅寶石	0.16ct Ruby

珠寶設計：林汶諭　Jewelry designer: Liliana Lin
珠寶金工：錡儷工坊　Jewelry goldsmith: Qi-Li Jewelry Workshop
攝影：許文星　Photographer: Wen-Hsing Hsu

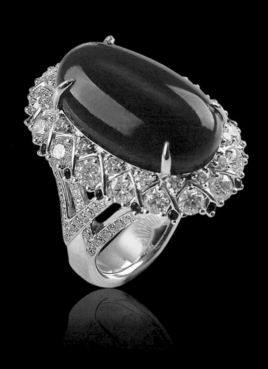

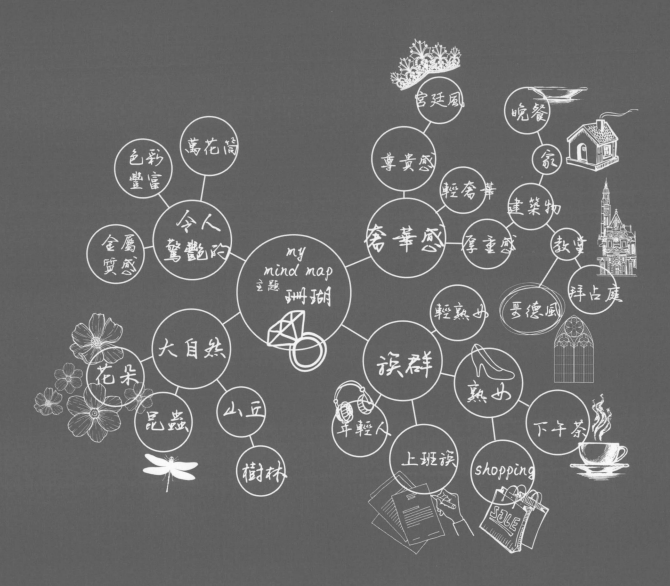

萬花筒

色彩豐富

金屬質感

令人驚艷的

宮廷風

尊貴感

輕奢華

晚餐

家

建築物

教堂

拜占庭

my mind map
主題 珊瑚

奢華感

厚重感

哥德風

大自然

花朵

昆蟲

山丘

樹林

族群

輕熟女

熟女

下午茶

年輕人

上班族

shopping

① ② ③ ④

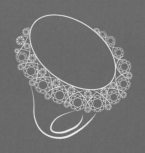

2016 年的九月我來到英國的 Salisbury Cathedral。 這種哥德式的建築,尖塔高聳、尖型拱門的教堂,深深吸引我。這個成為我創作的一個重要印象元素。這種哥德式的建築,尖塔高聳、尖型拱門的教堂,深深吸引我。這個成為我創作的一個重要印象元素。

於是我希望能夠將這種流暢的線條感,帶入我的珠寶設計當中,成為一個主要的元素。

思考如何讓這樣的元素既能夠保有簡潔的線條感,但是還是能夠展現出輕盈的質感,而不會繁重。於是我決定讓線條隱藏在寶石之間。

因為這是一顆高質感的珊瑚,希望能呈現一個強而有力的顏色對比之外,也能夠呈現細節的細膩度。所以,在最外圍使用很細緻的紅寶石來與主石互相呼應。

綠光下的蝴蝶

The Butterfly Under the Green Light

陽綠色，是翡翠最美麗的顏色。所以我希望透過翡翠這樣飽和美麗的色彩，詮釋出一件能夠跳脫傳統翡翠形象的作品，卻還是保有優雅美麗的氣質。因為這樣的設計理念，我利用蝴蝶美麗的線條與鑽石交錯在藍綠色寶石的中間！期望在展現設計概念同時，一樣具有市場性！

Bright green jade is the most beautiful shade of jade. Therefore, I hope to use the exquisite, saturated colors of jade to create a depiction that breaks away from the traditional image of jade while preserving its elegance and beauty. To achieve this design concept, I used the beautiful contours of a butterfly with interlocked diamonds amidst blue and green jewels! I hope that this work can successfully portray this design concept while also possessing marketability.

5 顆 翡翠		5pcs Jade
23.74g 18k 金		23.74g 18k Gold
0.92ct 鑽石		0.92ct Diamond
0.46ct 黃色藍寶石		0.46ct Yellow Sapphire
0.94ct 藍色藍寶石		0.94ct Blue Sapphire
1.12ct 綠色沙佛萊石		1.12ct GreenTsavorite

珠寶設計：林汶諭　　　　　　　　Jewelry designer: Liliana Lin
珠寶金工：錡儷工坊　　　　　　　Jewelry goldsmith: Qi-Li Jewelry Workshop
攝影：許文星　　　　　　　　　　Photographer: Wen-Hsing Hsu

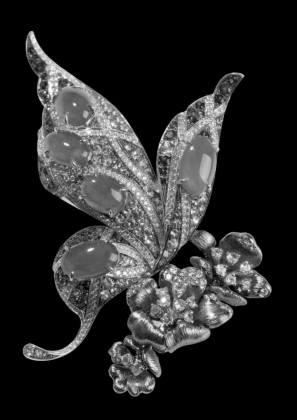
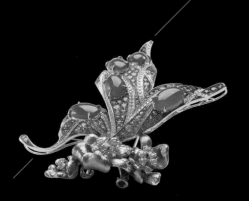

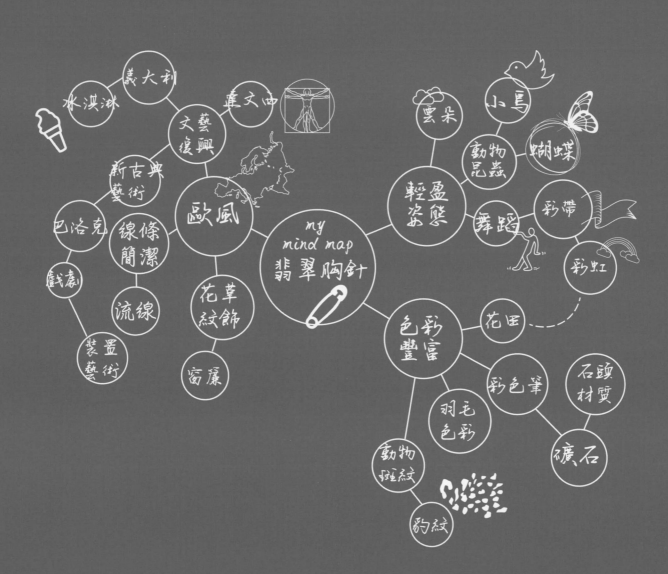

①

②

③

④

針對翡翠的設計，我不想承襲傳統的設計方式，所以採用了優雅的蝴蝶造型，跟前幾件設計一樣我取材側邊的蝴蝶姿態來為翡翠加分。

這時候我必須化繁為簡，擷取一個優美的姿態出來加以變型。

外型確立之後，考慮加進一些原始的構想元素，具有線條感的，歐式簡潔元素放進作品裡面。

進一步，利用鑽石放在線條的位置上，來加強藍與綠色的區別。最後，點綴上美麗的花朵，雛形就大功造成了。

綠光下的蝴蝶（耳環）

Emerald Luster Butterfly earrings

因為有了「綠光下的蝴蝶（胸針）」這一件作品，才有了這一件全耳式耳環的設計！為了讓這兩件作品成為一套，透過翡翠飽和且美麗的色彩，搭配上生動的線條，讓蝴蝶以跳躍式的姿態展現在耳朵上！這是一件可拆式的設計，既可以拆下來成為單純簡約的款式，符合一般場合現簡約高雅的姿態！也可以一組展現成為華麗而生動的效果，配合特殊場合配戴，讓搭配者更好運用！

The "Emerald Luster Butterfly" brooch inspired this earring cuff design. These two pieces were made into a set by utilizing emeralds of the most intense and beautiful colors, along with vivid lines that allow the butterflies to display a leaping posture on the ear. This is a detachable design that can be separated to create a simple and minimalist style, which suits the simple and elegant attitude of everyday occasions. It can also be worn as a set, creating a gorgeous and lively effect for special occasions, making accessorizing easier!

2 顆　翡翠	2pcs　Jade
18.98g 18k 金	18.98g 18k Gold
1.5ct　鑽石	1.5ct　Diamond
2.3ct　藍色藍寶石	2.3ct　Blue Sapphire
0.39ct　綠色沙佛萊石	0.39ct　GreenTsavorite

珠寶設計：林汶諭	Jewelry designer: Liliana Lin
珠寶金工：錡儷工坊	Jewelry goldsmith: Qi-Li Jewelry Workshop
攝影：許文星	Photographer: Wen-Hsing Hsu

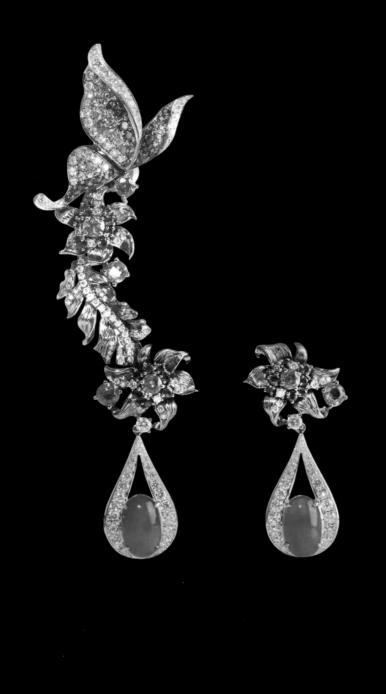
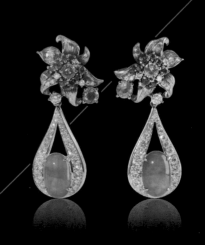

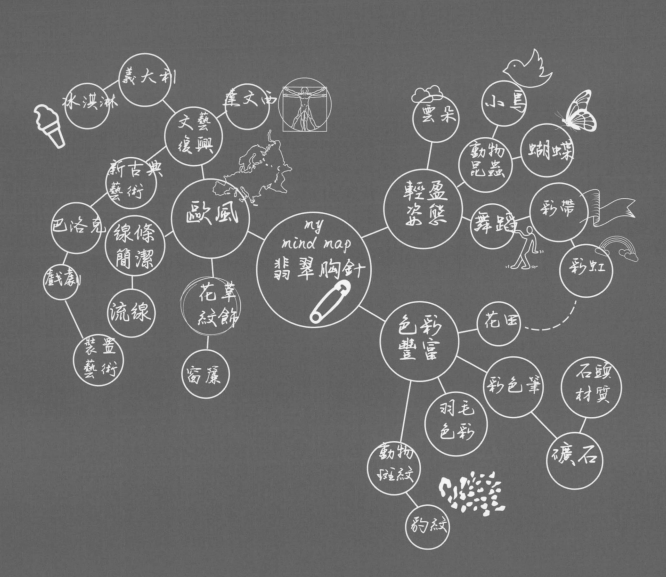

① ② ③ ④

這是一件全耳式的耳環,為了要跟胸針搭成一套,是很傷腦筋的一件作品。我先採用葉子活潑的造型來取材。

利用葉子與花朵設計成一組線條流暢的造型。

在放上與胸針同樣的蝴蝶造型之後。為了考慮配戴的多樣性,於是加上動人的綠色翡翠,並將設計成可拆式的耳環以因應不同場合的需要。

最後,我加上一些彩色寶石加強整體的活潑度,設計即大功告成。最後,製作上因為需浮貼於耳型之上確實煞費苦心,但是看到美麗的成品一切都值得。

印象佛羅倫斯

Ricordo di Firenze

2017 年的九月我來到義大利佛羅倫斯，就住在一個頗負盛名的觀光景點《老橋》。在義大利人身上發現一種說不上來的氣質，在輕鬆熱情的外表下卻有一股很古典的味道！這要如何形容呢？就像看似狂妄不羈的米開朗基羅，底蘊卻透露出羅馬式的榮耀！這個戒指是來自老橋的靈感，如同老橋一般明亮閃耀的瑰麗之下有著典雅的氣質。

In September 2017, I arrived in Florence, Italy and lived near a fairly well-known tourist attraction, the "Ponte Vecchio". I discovered that the Italians hold a certain quality that cannot be put into words. Underneath their carefree and warn appearance is a classical character. How does one describe this? It is as if seeing the divine Michelangelo; hidden yet exuding an air of Romanesque glory. This ring was inspired by the Ponte Vecchio and its magnificence sparkles as brightly as the Ponte Vecchio while concealing an aura of elegance.

2.09　莫三比克紅寶石	2.09　Mozambique ruby
9.41g　18k 金	9.41g　18k Gold
0.64ct 鑽石	0.64ct Diamond
尺寸：19.90mm × 27.22mm	Dimensions: 19.90mm × 27.22mm

珠寶設計：林汶諭	Jewelry designer: Liliana Lin
珠寶金工：錡儷工坊	Jewelry goldsmith: Qi-Li Jewelry Workshop
攝影：許文星	Photographer: Wen-Hsing Hsu

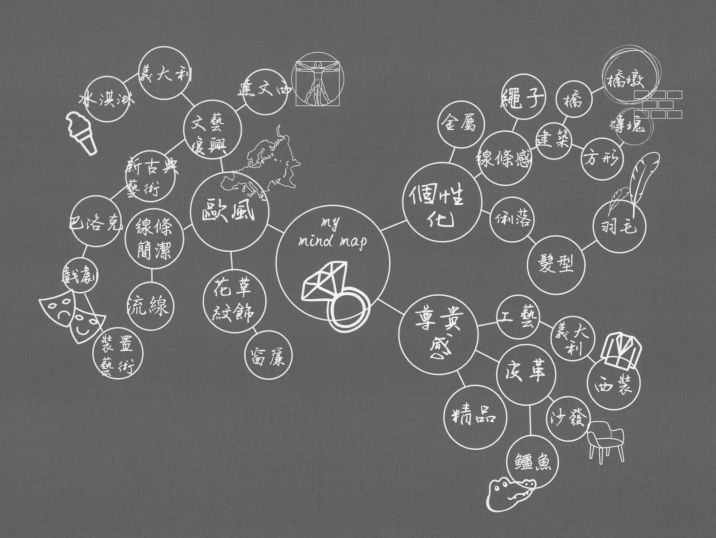

①

②

③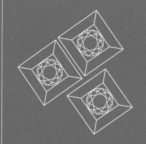

④

這是一個以「橋」為發想的設計主題。想創造一個既典雅有帶點前衛的造型感。

利用石橋邊石磚的意象,轉化成鑽石的造型。再利用橋墩的線條線條成為戒指上俐落的造型。

決定好題材之後,開始進行變形工作。將石磚化身成單顆閃耀的鑽石。

這時候,開始考驗師傅的工藝了。因為實際的製作過程需要利用方格進行交錯的線條感,所以實品設計更需要注意流線,製作難度也高。

花園

Flower Bed

這是一顆紫色，乾淨，透明的六線星石藍寶石，第一次看到就被它本身所散發出來的夢幻感所吸引！為了保有這樣的夢幻感，我取用了不同層次的紫色配石，期望能營造出夢幻又雅緻的作品。所以，我選擇了「花園」這樣的題材，創造出既簡約又不失活潑的特質。這也是一件兩用的作品，可以當戒指，也可以取下來當吊墜，增加其靈活度！

This is a purple, clean, transparent six-rayed star sapphire. Upon first glance, I was drawn to the dream-like feelings that it radiates! In order to maintain this sense of fantasy, I used different levels of purple stone, in the hopes of creating a dreamy and elegant piece. Therefore, I chose the theme of a "flower bed" to create a simple yet lively quality. This is also a dual-use piece. It can be used as a ring or as a pendant, thus increasing its flexibility!

6.22ct 六線星石藍寶石	6.22ct Star sapphire
23.44g 18k 金	23.44g 18k Gold
5.96ct 紫色水晶	5.96ct Purple crystal

珠寶設計：林汶諭	Jewelry designer: Liliana Lin
珠寶金工：錡儷工坊	Jewelry goldsmith: Qi-Li Jewelry Workshop
攝影：許文星	Photographer: Wen-Hsing Hsu

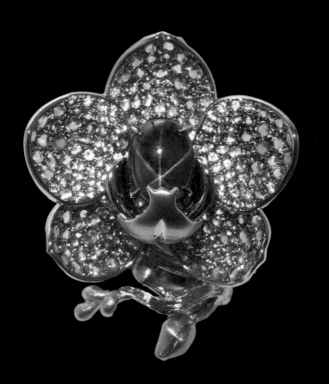
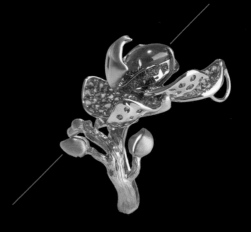

① ② ③ ④

當我拿到一顆很美麗的紫色 六線星石藍寶石，我的第一 個想法是如何呈現這種夢幻 的感覺。於是，嘗試在美麗 大自然當中找尋靈感。

從眾多的花朵造型當中，選 擇了一個很適合這個紫色六 線星石的形象－蝴蝶蘭。

大自然的題材非常豐富。但 是，難免存在一些不和諧的 因素。所以，這裡需要將花 型進行變型，成為一個全新 的造型。

外型調整之後，就需要再調 整一下內部。進一步簡化內 部構造，並縮短花萼的長度， 以凸顯主石的美麗。再點綴 上幾個小花苞，加強豐富度。

兩個系列的耳環設計（雲紋系列與花朵系列），是針對年輕時尚的女性而發想的作品。雲紋系列的設計，融入中國風的元素，看起來卻不繁重！花朵系列，簡單又不失典雅的樣式，適合每一個場合的需要。

The two earring design series (Moire series and Flower series) are works for young, fashionable women. The design of the Moire series is integrated with elements of the Chinese style, rich in oriental colors without exuding a heavyambience! The Flower series is simple and fresh yet elegant, suitable for every occasion.

珠寶設計：林汶諭
珠寶金工：錡儷工坊
攝影：許文星

Jewelry designer: Liliana Lin
Jewelry goldsmith: Qi-Li Jewelry Workshop
Photographer: Wen-Hsing Hsu

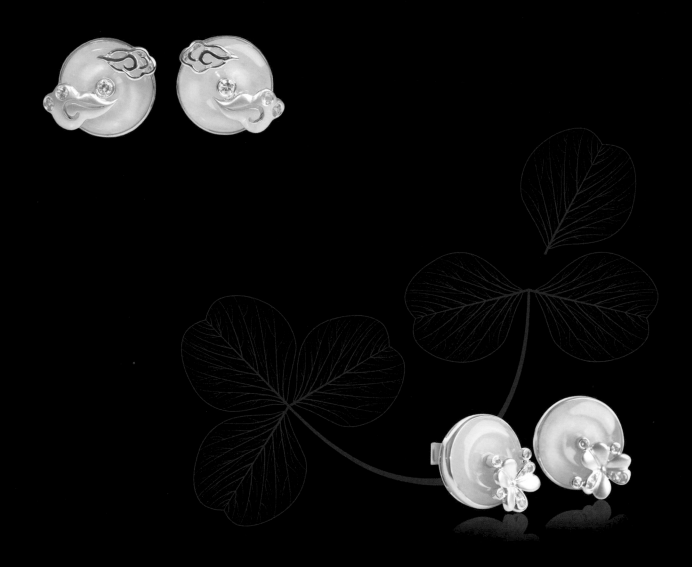

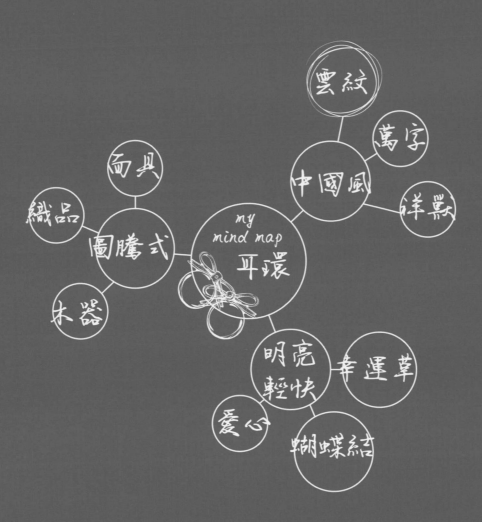

① ② ③ ④

翡翠懷古是很常見的寶石，這裡想要給予一個輕巧的形象，在心智導圖的過程中，發想出一個很中國式古典的創意，希望一樣能為翡翠帶來不同的耳目一新。

在眾多雲紋中，參考了雲紋型象之後，設計出其中一款，完全以線條來呈現。

搭配前一組的元素題材，這裡加以設計另外一個雲紋的造型來與前面一組前後呼應，呈現出一實一虛的對比效應。

整件作品想要呈現一個乾淨純淨的感覺，所以每個組件都沒有使用爪鑲的概念，這會加重製作上的難度，但是也讓作品更加輕巧與乾淨。

心智圖
Mind Map

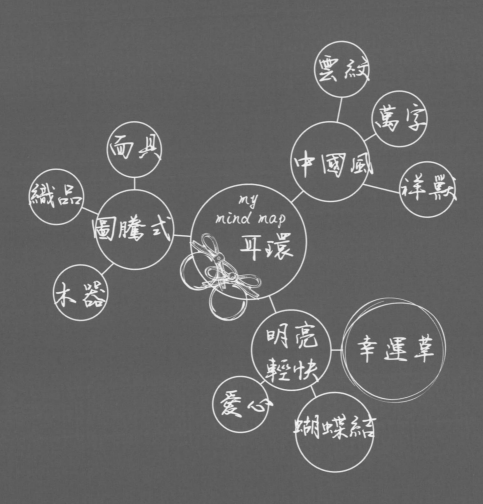

① ② ③ ④

翡翠懷古是很常見的寶石,這裡想要給予一個輕巧的形象,在心智導圖的過程中,發想出另一個很可愛又富含幸運意義的圖騰,希望一樣能為翡翠帶來不同的耳目一新。

幸運草幾乎不大需要變型,先把基本型確立之後,想富與一點小小不同的創意,所以這裡將葉子改成弧度型態。

搭配上彩色寶石來增加一點趣味性。

最後在懷古正中間放上一顆比較大顆的彩色寶石,就完成整個設計流程了。

來自上帝的禮讚

Praise from God

美麗的色彩就像是上帝的畫筆，呈現出令人讚嘆的珠寶藝術！我嘗試使用對比的色系加強色彩的層次。運用流線的樹葉線條與祖母綠、翡翠相呼應。

Every time I see a beautiful and intensely colored gem, I can only commend its creator in amazement! I tried to use a contrasting color system to enhance the color gradation. Streamlined leaves are used, which echo the emerald and jade.Beautiful gems are like God's brushes. They present a magical jewelry art!

4.3ct	祖母綠	4.3ct Emerald
6 顆	翡翠	6 pcs Jade
1.42ct	鑽石	1.42ct Diamond
0.35ct	黃色藍寶石	0.35ct Yellow sapphire
尺寸：2.2cm × 2.6cm		Dimensions：2.2cm × 2.6cm

珠寶設計：林汶諭	Jewelry designer: Liliana Lin
珠寶金工：錡儷工坊	Jewelry goldsmith: Qi-Li Jewelry Workshop
攝影：許文星	Photographer: Wen-Hsing Hsu

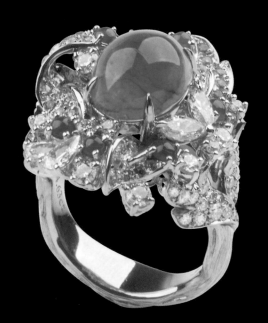
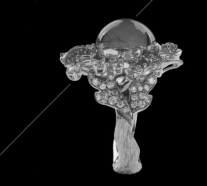

心智圖

Mind Map

音符　音樂
　　　畫作
　藝術
花　令人
　　驚艷

山水　潑墨
　　　　工筆畫

調色盤
顏料
　　　編織
　布料　染料
色彩　　　圖騰
豐富
my mind map 綠色
　　　花田
　　　　彩虹

自然元素
　　　天空　雲
　　山川
動物　　　雨
斑紋　羽毛
　　　　支流
斑馬紋　樹林
　　　　葉子　花
豹紋　海浪

① ② ③ ④

首先，當我拿到一顆美麗的
寶石，就會萌生很多想法。
以這個例子來說，我利用心
智圖，發想了一個上帝調色
盤的概念，想賦予活潑豐富
的意涵。

選擇了葉子做為環繞在主石
旁的主軸之後，我必須針對
葉子這一個素材加以變型，
讓這樣的素材能夠符合整體
得型象與概念。

進一步決定由三片葉子穿梭
其中，另外，也需要利用葉
子製造一些活潑的動態。

最後也是最複雜的狀態，我
希望利用寶石與高低反差試
圖營造出豐富的動態感。

夢
幻

Dream

翡翠一直是中國人的最愛，而紫色翡翠讓翡翠多了一份柔美的效果。
這個夢幻的紫色，讓我決定運用了流暢的線條與圓潤的感覺，製造出
精緻古典的造型，襯托起典雅的紫色夢幻。

Jade has always been a favorite with Chinese people. Purple jade adds
a gentle and beautiful effect to the jade. This dreamy purple made me
decide to use smooth lines and a mellow feeling to create a refined and
classic shape, accentuating an elegant purple dream.

4.8g　紫色翡翠	4.8g　Purple Jade
14.47g 18k 金	14.47g 18k Gold
1.40ct 鑽石	1.40ct Diamonds
0.40ct 紫色水晶	0.40ct Purple crystal
尺寸：2.5cm × 2.7cm	Dimensions: 2.5cm × 2.7cm

珠寶設計：林汶諭	Jewelry designer: Liliana Lin
珠寶金工：錡儷工坊	Jewelry goldsmith: Qi-Li Jewelry Workshop
攝影：許文星	Photographer: Wen-Hsing Hsu

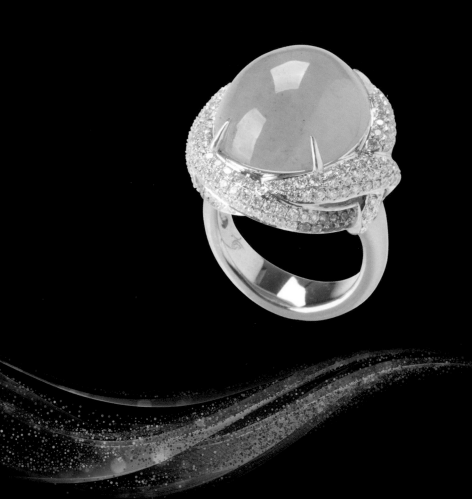

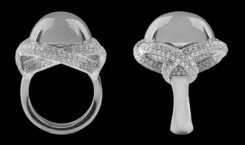

① ② ③ ④

當我拿到一顆種水很好的紫色的翡翠，呈現出很雅致的柔美。我思考如何跳脫中式的感覺又仍然展現優雅！於是，我使用歐式這種繩結的感覺，讓整體感既優雅又有一種安靜的美。

這種歐式的繩結種類非常多，可是有些樣子使用起來卻讓整體感不協調。這個部份思考很久，才決定上面這個圖型的繩結是比較適合的，但是，還是需要調整並加以變型！

這是最後定案的效果，整體感協調不衝突。

再來就需要思考配石的搭配效果。所以，在下圍的部分呈現半圈的紫色。既可以看出線條的美感之外，也不會突兀。

思念 — 老家

Missing home

這是以故鄉老家的老樹為主題，作為設計概念。雖然現在故鄉的老家牆面已經斑駁不堪，和旁邊的新建築呈現一個很強的對比。但是，這面斑駁堪的牆面在我這個遊子眼中，永遠是充滿回憶的美麗！

The theme of an old tree in my hometown is used as the design concept. The walls of my house in my hometown are now mottled, it stands in strong contrast with the new building next to it. However, as someone who left home long ago, this mottled wall will always be full of beautiful memories in my eyes!

-

2017 國際時尚翡翠首飾設計大賽（B）成品公開組 入選
2017 International Design Competition on Trendy Fei Cui Jewellery

5 顆　翡翠	5 pcs　Jade
16.16g 18k 金	16.16g 18k Gold
0.68ct 鑽石	0.68ct　Diamond
1.03ct 粉色藍寶石	1.03ct　Pink sapphire
1.31ct 沙佛萊石	1.31ct　Tsavorite

設計師：林水吉	Jewelry designer: Shui-Ji Lin
珠寶金工：錡儷工坊	Jewelry goldsmith: Qi-Li Jewelry Workshop
攝影：許文星	Photographer: Wen-Hsing Hsu

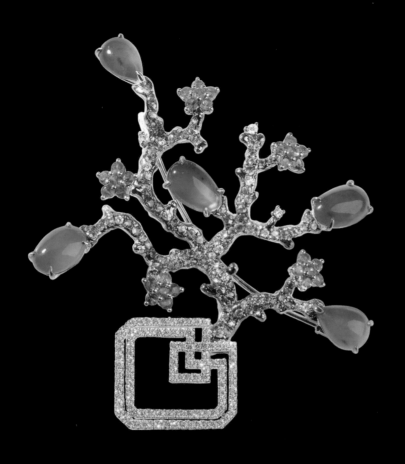

Design the dream

手繪稿賞析
Hand painted manuscript

來自上帝的禮讚 *Praise from God*

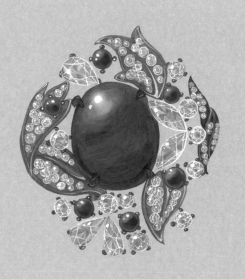 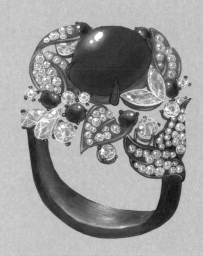

我的哥德式印象 *My Gothic Impression*

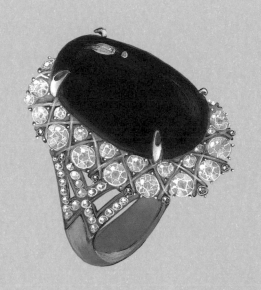

花園 *Flower Bed*

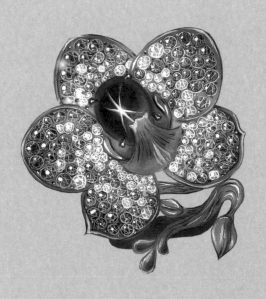

女神 *Wedjet*

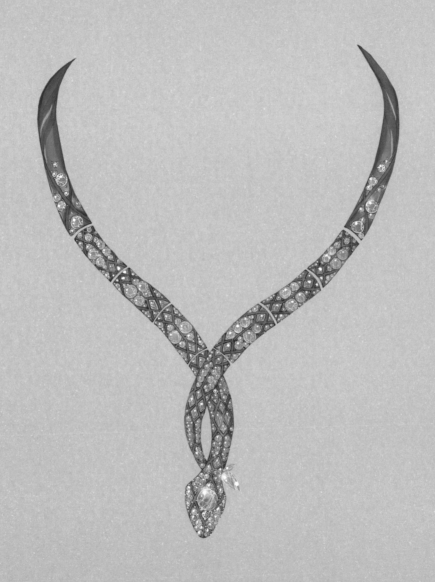

夢幻 *Dream*

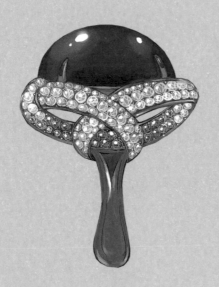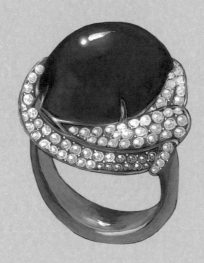

綠光下的蝴蝶 *The Butterfly Under the Green Light*

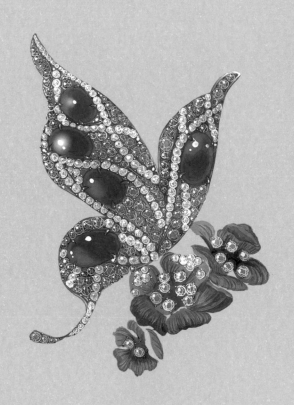

綠光下的蝴蝶（耳環）*Emerald Luster Butterfly earrings*

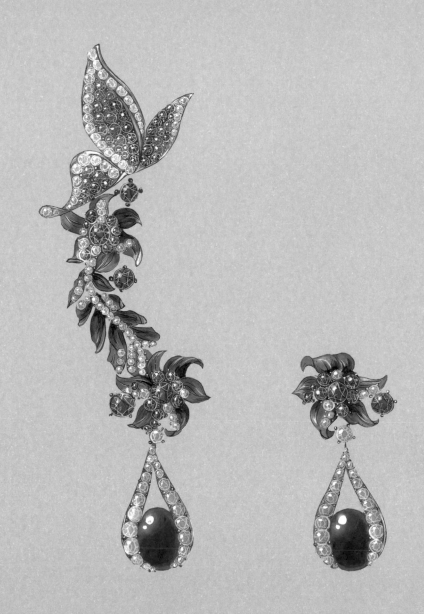

In order to be irreplaceable one must always be different.
—— *Coco Chanel*

11g 正紅色的阿卡珊瑚__ / 14.66g 18k
金 / 0.37ct 鑽石____ / 0.56ct 桃紅色藍
寶石 / _____ 11g Red Aka Coral 14.66g
/ 14.66g 18K Gold _____ / 0.37ct
Diamonds ____ / 0.56ct Pink Sapphires

02

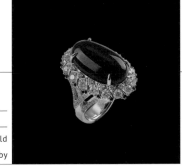

____ 2.764g 阿卡珊瑚 / 12.26g 18k 金__
2.32ct 鑽石_____ / 0.16ct 紅寶石 /____
2.764g Red Aka Coral / 12.26g 18K Gold
____ 2.32ct Diamonds /____ 0.16ct Ruby

04

05

翡翠 /____ 23.74g 18k 金 / 0.92ct 鑽石 / 0.46ct
__黃色藍寶石 / 0.94ct 藍色藍寶石 / 1.12ct 綠色
沙佛萊石 /____ Jade / 23.74g 18k Gold / 0.92ct
Diamond / 0.46ct Yellow Sapphire ____ / 0.94ct
Blue Sapphire _____ / 1.12ct GreenTsavorite

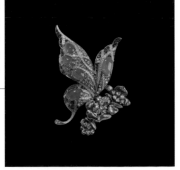

08

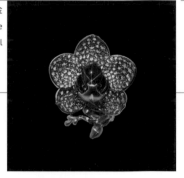

__ 6.22ct 六線星石藍寶石 / __ 23.44g 18k 金
__ / 5.96ct 紫色水晶 / 6.22ct Star sapphire
/ 23.44g 18k Gold __ / 5.96ct Purple crystal

10

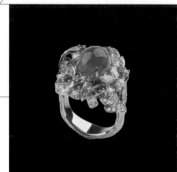

____ 4.3ct 祖母綠 / 6 顆 翡翠 / ____ 1.42ct
鑽石 / __ 0.35ct 黃色藍寶石 / 尺寸：2.2cm ×
2.6cm / 4.3ct Emerald / ____ 6 pcs Jade /
1.42ct Diamond / __ 0.35ct Yellow sapphire
____ / Dimensions : 2.2cm × 2.6cm _____

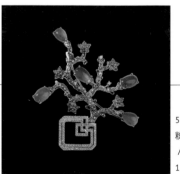

5 顆 翡翠 / 16.16g 18k 金 / 0.68ct 鑽石 / 1.03ct
粉色藍寶石 / 1.31ct 沙佛萊石____ / 5 pcs Jade
/ 16.16g 18k Gol / _____ 0.68ct Diamond /
1.03ct Pink sapphire _____ / 1.31ct Tsavorite

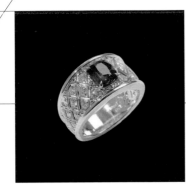

/ 2.09 莫三比克紅寶石__ / 9.41g 18k 金
_____ / 0.64ct 鑽石 / 尺寸：19.90mm ×
27.22mm / 2.09 Mozambique ruby ____ /
9.41g 18k Gold __ / 0.64ct Diamond / __
_____ Dimensions: 19.90mm × 27.22mm __

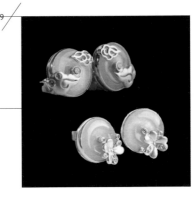

____ 4.8g 紫色翡翠 / 14.47g 18k 金 / 1.40ct
鑽石 / 0.40ct 紫色水晶 / _____尺寸：2.5cm
× 2.7cm / 4.8g Purple Jade __ / 14.47g 18k
Gold / ___ 1.40ct Diamonds / 0.40ct Purple
crystal / Dimensions: 2.5cm × 2.7cm _____

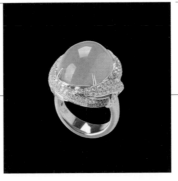

創作者介紹
Introduction

珠寶設計師
Jewelry designer

林汶諭
Liliana Lin

台灣珠寶設計師，佛光大學藝術學系碩士，英國寶石協會寶石鑑定師。汶諭自幼習琴學畫，浸淫於

藝術領域並享受學習與創造之樂趣，從書畫中探求生活美學，在琴聲裡追尋感性與理性的平衡。當

我進入珠寶設計領域的那一霎那，早年的藝術素養遂成為養份，為我的珠寶設計作品注入靈魂與生

命。因為我相信唯有豐富的藝術能力，才能孕育出更多元且具有生命底蘊的作品！

Taiwanese jewelry designer, Master of Arts from the Department of Art Studies at Fo Guang

University, Gemologist with the Gemmological Association of Great Britain. Since childhood,

Wen-Yu has studied piano and painting, immersed herself in the field of art and has enjoyed

learning and creation. She has soughtthe aesthetics of life through calligraphy and painting,

and has pursued the balance between sensibility and rationality in the piano's sound. When

I entered the field of jewelry design, my early years of artistic literacy became nutrients,

專業證照與履歷：GEM-A 英國寶石協會寶石鑑定師 / TGI 同濟大學寶石

injecting soul and life into my jewelry design. This is because I believe that only rich artistic

鑑定師 / 台北市珠寶產業工會理事 / 台灣聯合珠寶玉石鑑定中心 顧問

ability can give birth to more diverse works which contain the essence of life!

作品展與參賽經歷：亞太珠寶設計師台北福華展 / 台北光點個人創作展 / 草

山行館個人創作展 / 2015 杜拜珠寶設計獎 / 2016 中國足金首飾設計大賽

金工師
About the Metalworking

林水吉

Shui Chi Lin

水吉很小就從事金工這個行業，一開始只是想學習一門興趣。但是，一踏入這個領域之後，

就被這個領域吸引數十年！金工，是一個很特殊產業，這是一個界於藝術與工藝之間的領

域。除了要達到設計師的美感與要求之外，還要能夠處理製作方面的難度。從工藝的角度

出發，進而探索藝術的美學！這是一門永遠學習不完的行業！

Shui-Chi has worked in the field of metalworking ever since he was very young.

At first, he only took up metalworking as a hobby. However, once he began learning about metalwork, he ended up immersing himself in the field for several decades! Metalworking is an extremely unique industry that lies on the boundary between arts and crafts. In addition to fulfilling the designer's aesthetics and requirements, it is also necessary to be able to handle the difficulty of the creation process. Metalworking is an aesthetic that is derived from a crafts perspective and further explores art. In the metalworking industry, there is always something new to learn!

台灣資深金工師，錡儷工坊負責人

Senior Metalworker in Taiwan / Supervisor of Qi-Li Jewelry Workshop

許文星

Wen Hsing Hsu

文星因為自小學習藝術領域，1991 年因緣際會進入攝影業服務至今。珠寶業的

攝影一直是很具挑戰性的。珠寶是高質感的產品，需要比其他產品更忠於原作的

色彩與設計理念，所以與設計師先行溝通也是一門很重要的課題！

Wen-Hsing has studied art ever since he was in elementary school. In 1991, he took the opportunity to enter Good Photo

Studio, and has worked there ever since. Jewelry photography is very challenging. Although jewelry are high quality products,

their images require a higher degree of fidelity to the colors and design concept of the original work than other products.

台灣藝術學院工藝設計藝術學學士 / 好映相攝影有限公司負責人

Therefore, communicating with designers in advance is also a matter of extreme importance!

Bachelor of Arts, Crafts & Design Department, National Taiwan University of Arts / Supervisor of Good Photo Studio

ISBN 978-957-43-6222-6

中 文 書 名　創造優雅靈魂
英 文 書 名　Jewellery Design by Liliana
作　　　者　林汶諭
手 繪 稿　林汶諭
影 像 設 計　林汶諭
插　　　圖　林汶諭
　　　　　　部分插畫圖片來自 shutterstock
攝　　　影　許文星
裝 幀 設 計　楊維綸
封 面 設 計　楊維綸
出 版 者　林汶諭
代 理 經 銷　白象文化事業有限公司
E m a i l　psbook3@gmail.com
地　　　址　40144 台中市東區和平街 228 巷 44 號
電　　　話　04-2220-8589
傳　　　真　04-2220-8505
初 版 一 刷　2019 年 02 月
精 裝 訂 價　新台幣 1880 元
I S B N　978-957-43-6222-6 （精裝）
印　　　刷　鑫益有限公司

國家圖書館出版品預行編目（CIP）資料

創造優雅靈魂 / 林汶諭作 . — 初版 . —
新北市：林汶諭 , 2019.02
94 面；19 × 23 公分
ISBN 978-957-43-6222-6（精裝）

1. 珠寶設計　2. 作品集
968.4　　　　　　　　　　　　　　　107021746